EAST LONDON

An opinionated guide

Written by
SONYA BARBER

Photography by
CHARLOTTE SCHREIBER

Information is dead.
Long live opinion.

A dangerous statement in a world of fake news,
but there you go: this book contains the best places to eat, shop
and enjoy in Hackney and beyond – outrageously skewed to our
book-loving, gallery-visiting, dog-walking, food-munching tastes.

How dare we? Because we live here, we work here and we make
books about East London. And because, in a world of abso-
lutely-everything-is-available what matters is well-informed
opinion, not dry data and facts. OK … our grandfather was
not born here. But nor was yours. (Apologies if he was.)

These are not the coolest placest to go. (We almost put Westfield
Stratford shopping centre in the mix.) These are not the
newest. And they certainly aren't the only places to go. These
are the places we'd take you to if you were to stay with us, not
trash our home, and wanted a very good time, thank you.

Do we find gentrification uncomfortable? Often.
Do we love a great coffee. Always. Oh, the contradiction...
screw it, these are the places we *love*.

Ann and Martin
Founders, Hoxton Mini Press.

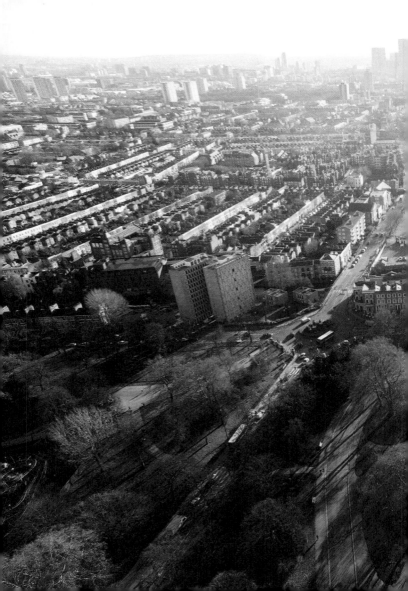

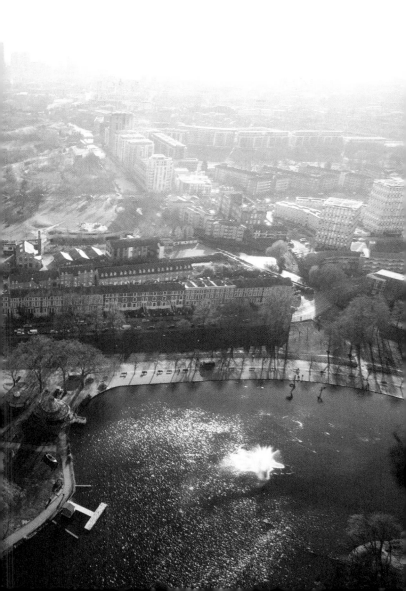

A Perfect Weekend

Friday night
Kickstart the weekend with a fragrant feast
at Berber & Q (no.29) before catching an
experimental gig at Café Oto (no.52). Finish the
night right with cocktails at Ruby's (no.55).

Saturday morning
Clear your head with a stroll around Victoria
Park (no.38), having breakfast at Pavilion
Café (no.25). Swing by Chisenhale Gallery
(no.45) for an art fix, before walking along
the canal to Broadway Market (no.37).

Saturday lunch
Stop for a coffee at Climpson & Sons (no.16) before
navigating the food stalls and dropping in to see
the latest arrivals in Donlon (no.8) and Artwords
(no.1). Wend your way to Bistrotheque (no.22)
for a leisurely late lunch and a bloody mary.

Saturday afternoon
Walk to Shoreditch via the canal for a shopping
spree, stopping off at Labour and Wait (no.5),
Aida (no.7), SCP (no.11) and Tokyobike (no.4). Then
refuel with a coffee and snack at Leila's Shop (no.19).

Saturday evening
Savour a well-earned glass of something at Sager
+ Wilde (no.51) or The Marksman (no.50), before
dinner at Morito (no.28). Head to Moth Club
(no.56) afterwards for dancing until late.

Sunday brunch
Wake up with a swim at London Fields Lido
(no.40) and breakfast at E5 Bakehouse (no.24)
a few hundred yards away. Buy flowers at
Columbia Road flower market (no.39) and look
over the wares in Choosing Keeping (no.2).

Sunday afternoon
Visit the Beigel Shops (no.34), then meander down
Brick Lane to Brick Lane Bookshop (no.10), then
head to Libreria (no.6) and Nude Espresso (no.17),
and end up at the Whitechapel Gallery (no.44).

Sunday evening
Catch an early screening at Genesis Cinema
(no.53) then eat Vietnamese at BúnBúnBún
on Kingsland road (no.26). Pop into the
Ace Hotel (no.14) for a nightcap before you
head home – or check in for the night.

Hackney: A Brief Overview

Shoreditch – crowds gravitate here for the ever-expanding selection of restaurants, bars, shops, hip hotels, street food stalls and nightlife. Fun and colourful but at times a little in-your-face.

Dalston – Centred around Kingsland High Street, this is the home of great late-night Turkish food, cheap Ridley Road Market groceries, basement dive bars and messy nights out.

London Fields – The eponymous green space and its surrounding streets attract dog walkers, lido swimmers, coffee-lovers, hipster barbecuers and a Saturday surge of Broadway Market goers.

Victoria Park – Picturesque residential streets surround this vast green space, alongside which lies a quaint cluster of local shops, cafés and pubs known as Victoria Park Village.

Hackney Central – The heart of the borough. Busy Mare Street is lined with high-street shops, council buildings and pubs.

Hackney Wick – artists' studios, warehouses and the Olympic Stadium are found in this spacious former industrial area.

Clapton – Over the last few years this has become the latest Hackney hotspot, with a constant stream of exciting new bar, café and restaurant openings.

Stoke Newington – Families, creatives and trendy brunchers flock to Stoke Newington Church Street for its shops, cafés and green spaces.

Stamford Hill – with the largest Hasidic Jewish population in Europe, this quiet neighbourhood stretches up to Tottenham and houses the Stokey overspill.

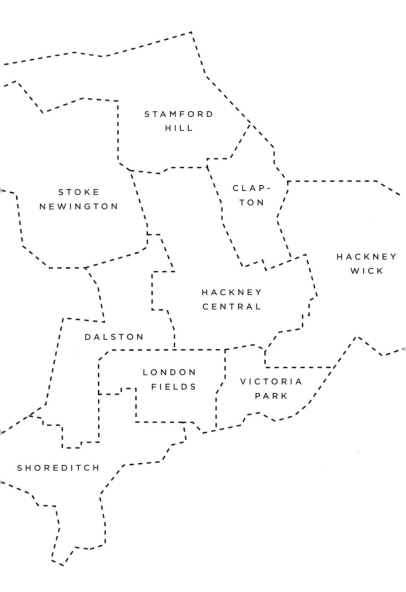

1

Artwords
Bookshop

Your coffee table never needs to look underdressed again, thanks to this pair of impressive art bookshops that offer so much more than the usual run of gorgeous tomes on contemporary art. You'll find rare imports and a hefty selection of hard-to-come-by magazines from across the world, covering topics ranging from architecture to advertising. It makes for wonderful browsing, and the staff really know their stuff.

69 Rivington Street, EC2A 3AY
and 20-22 Broadway Market, E8 4QJ
artwords.co.uk

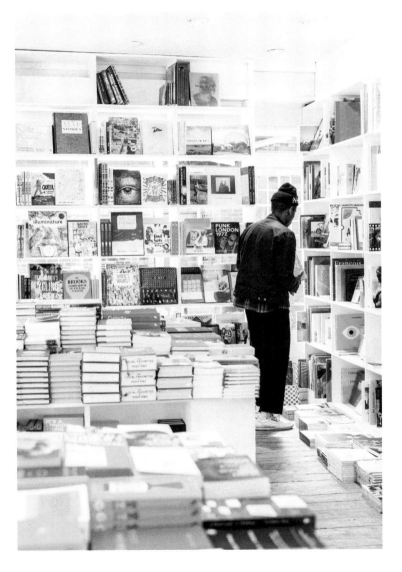

2
Choosing Keeping
Stationery shop

Situated on one of East London's most
picturesque streets, Choosing Keeping harks
back to an era of penmanship and letterheads,
of marbled writing supplies, Japanese
mechanical pencils, ornate wrapping paper,
elegant notebooks, dainty pots of colourful ink
and heirloom scissors – all placed as diligently
as the dot on a calligrapher's letter *i*. This is
stationery almost too precious to be used.

128 Columbia Road, E2 7RG
choosingkeeping.com

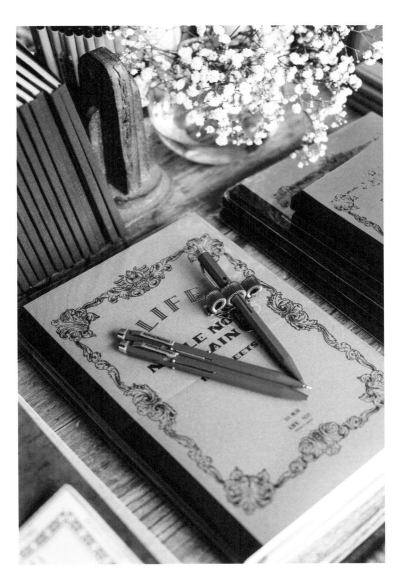

3

Conservatory Archives

Plant shop

If Kew Gardens is just too far away, then enjoy (and buy) the meticulously chosen houseplants at this Hackney hothouse which will fulfil all your botanical desires. The former ironmongery is stuffed floor-to-ceiling with a luscious, immaculately presented forest of succulents and horticultural exotica with which to lavishly decorate your home or work. Allow plenty of time to browse the chunky palms, delicate hanging plants and angry-looking cacti.

493-495 Hackney Road, E2 9ED
conservatoryarchives.co.uk

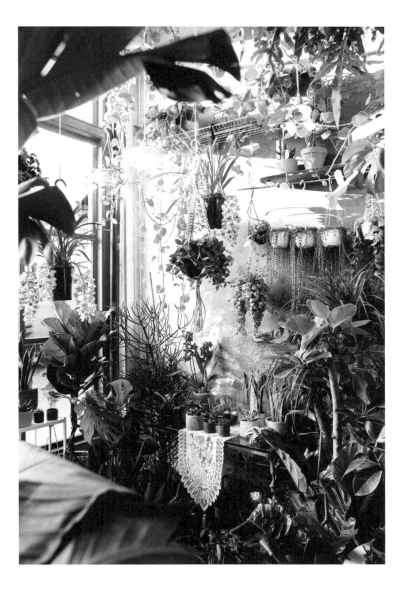

4

Tokyobike
Cycle shop

Fact: there's no cycling shop more minimal
and stylish than Tokyobike. Second fact:
everyone already knows this. But still, the
minimal décor provides the perfect setting
for its simple, beautifully designed bikes, plus
fashionable accessories (from waxed raincoats
to leather handlebar grips and bronze pedals)
to pimp your ride. Leave time to gawp at the
beautiful Japanese trinkets and inspirational
cycling books, and make sure you also invest in
a hefty (and fabulous) lock while you're at it.

87-89 Tabernacle Street, EC2A 4BA
tokyobike.co.uk

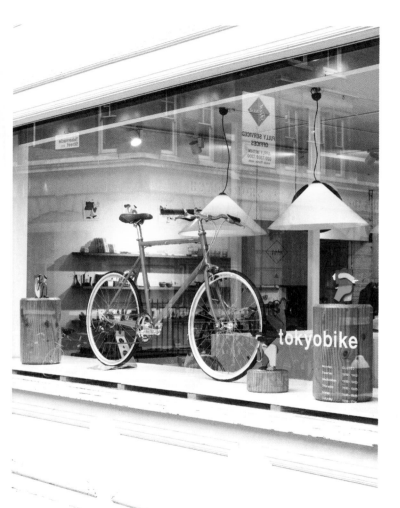

5

Labour and Wait
Homeware

Ration-book chic is the order of the day at
this unashamedly nostalgic homeware store.
You'll find you never knew you needed a
brass pen until it calls to you from among
the speckled enamel baking trays, beeswax
candles, wooden gardening tools, canvas
fisherman's smocks and straw brooms. If beauty
can be found even in life's most mundane
objects, this place has surely found it.

85 Redchurch Street, E2 7DJ
labourandwait.co.uk

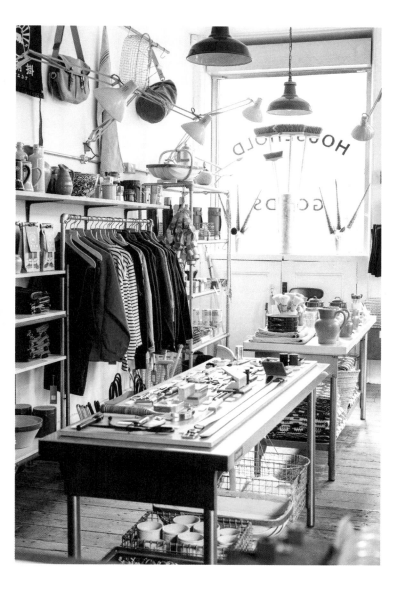

6
Libreria
Bookshop

With no coffee or wifi, just endless shelves of gorgeous books, Libreria bills itself as a refuge from the digital (at last, an escape!) Just off Brick Lane, it will reignite your love for the physical book with its beautiful special editions, fanzines, art publications, risograph printing workshops and poetry readings. It's open late from Thursday to Sunday, giving you plenty of time to curl up and read in one of the cosy cubbyholes built right into the shelves.

65 Hanbury Street, E1 5JP
libreria.io

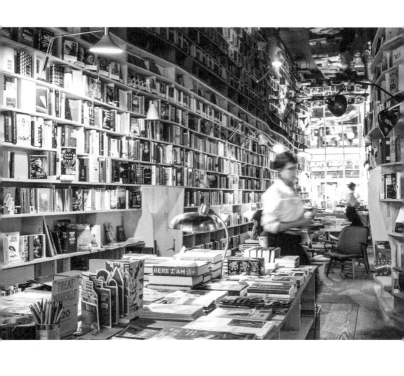

7
Aida
Fashion and homeware

Everything at this airy post-industrial concept
store has been painstakingly considered, from
the idiosyncratic styling by independent
European designers to the retro grooming
supplies (non-ironic, honest), through to
the locally-sourced homeware, hand-picked
book selection and vintage hairstyling parlour.
There's even a tranquil little café serving
cold-pressed juices and brightly coloured lattes.

133 Shoreditch High Street, E1 6JE
aidashoreditch.co.uk

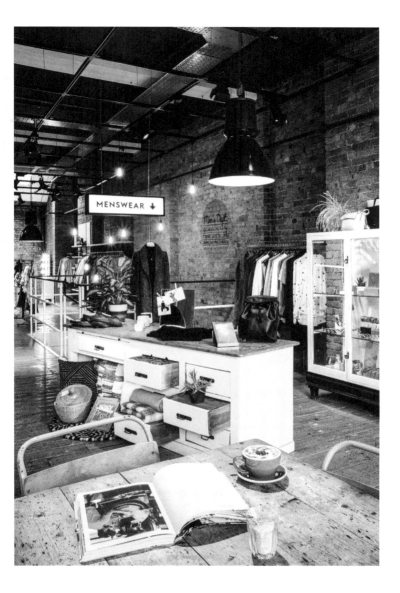

8

Donlon

Bookshop

Dropping in to this eclectic independent
bookshop is always a treat. Conor Donlon
makes his pick of new books from the worlds
of art, poetry, fashion, music, photography
and LGBT literature, hosts book launches
and readings and sources rare vintage finds,
artists' monographs and exhibition catalogues.
The selection is personal, current and
exciting – and if you're looking for something
specific, Conor will track it down for you.

75 Broadway Market, E8 4PH
donlonbooks.com

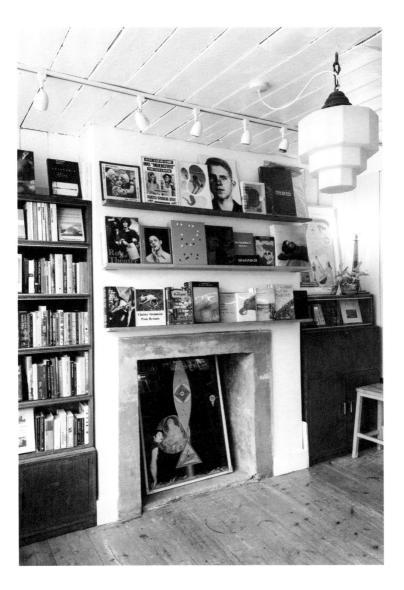

9

Triangle

Homeware and fashion

Three friends set up this independent
design store because of their shared love
of beautiful things – clothes, jewellery,
homeware, toiletries, furniture, and plenty
of other stuff that's guaranteed to look
elegant in your home. It's a celebration of
good, simple design and a one-stop shop
for all your Scandinavian minimalist and
Japanese monochrome design needs.

81 Chatsworth Road, E5 0LH
trianglestore.co.uk

10

Brick Lane Bookshop
Bookshop

This little bookshop is a love song to East
London and an essential pit stop for anyone
ambling up Brick Lane. Historical gems and
Ordnance Survey maps share the shelves with
London photography books, work by local
artists, guides to East End coffee shops, hidden
walks and street art (it is Brick Lane after all).

166 Brick Lane, E1 6RU
bricklanebookshop.org

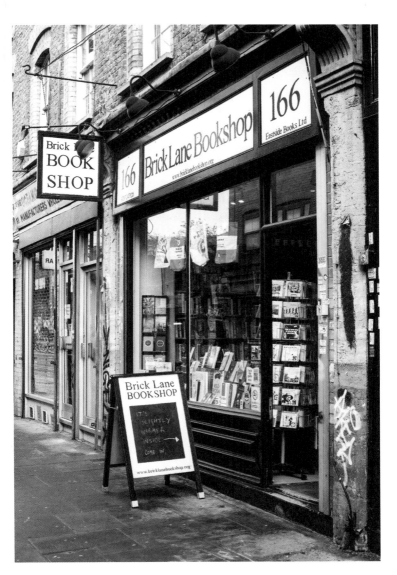

11
SCP East
Design, furniture and homeware

A three-floor design mecca full of intensely desirable things to kit out every room, Sheridan Coakley's seminal flagship store has been furnishing the homes of design-hungry East Londoners since the gentrification stone age (1985, to be exact). Future design stars share space with established names, and you can pick up anything from affordable kitchen accoutrements to eye-wateringly expensive 'investment' furniture. Sip on a piccolo at the in-house coffee shop while you contemplate splashing some cash.

135-139 Curtain Road, EC2A 3BX
scp.co.uk

12

The Culpeper

Hotel, pub and restaurant

If you've ever dreamed of living in Spitalfields, then staying at one of the homely rooms above this impressive corner pub and restaurant is a satisfying (albeit temporary) substitute. Their attitude to the five bedrooms is informal and relaxed, like staying in a well kitted-out Airbnb. It's perfect as a comfy crash pad after a late night out in East London – or just a conveniently short stumble from a night at the bar downstairs.

40 Commercial Street, E1 6LP
theculpeper.com

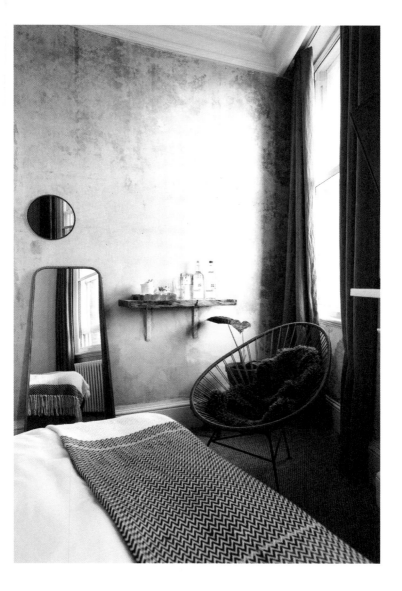

13

Town Hall Hotel

Hotel and restaurants

Back when Bethnal Green council had
money to burn, it splurged on a town
hall in high Edwardian baroque style. A
century on, its green and white marble,
lustrous teak, ornamental plasterwork and
art deco furnishings were rescued from
disrepair in its resurrection as a sumptuous
luxury hotel. With suites larger and better
equipped than a suburban family home,
and rooms that wittily blend retro and
up-to-the-minute contemporary design,
you won't want to set a foot outside.

8 Patriot Square, E2 9NF
townhallhotel.com

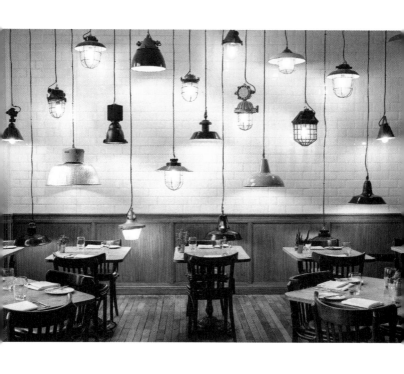

14

Ace

Hotel and restaurant

This ridiculously hip boutique hotel has
everything you need for the full Shoreditch
experience (though you'll have to bring
your own facial hair). A workspace by day
overflowing with laptops and flat-tops,
at night Ace's lobby transforms into a
lively late-night bar full of creative types
passing between the Hoi Polloi restaurant,
basement club Miranda and the glass roof
terrace. Each of the rooms is kitted out with
covetable mid-century furniture and (of
course) a turntable with record selection.

100 Shoreditch High Street, E1 6JQ
acehotel.com/london

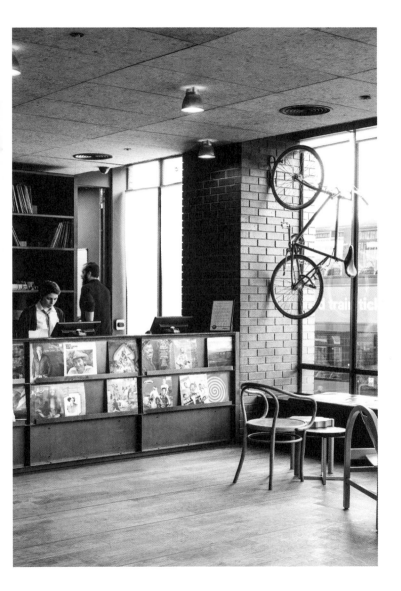

15

Ozone

Coffee shop and roastery

Of course this Kiwi-owned roastery makes
an excellent cup of Joe: they roast their own
beans and serve it impeccably via Aeropress,
v60 and all the other ways the cool kids
brew these days. But unlike some of their
caffeine-slinging rivals, the food at Ozone
is just as much of a draw. The brunch menu
is so much more than your usual breakfast
fare (get the cornbread with fermented chilli
butter), and yes, it's worth queuing for.

11 Leonard Street, EC2A 4AQ
ozonecoffee.co.uk

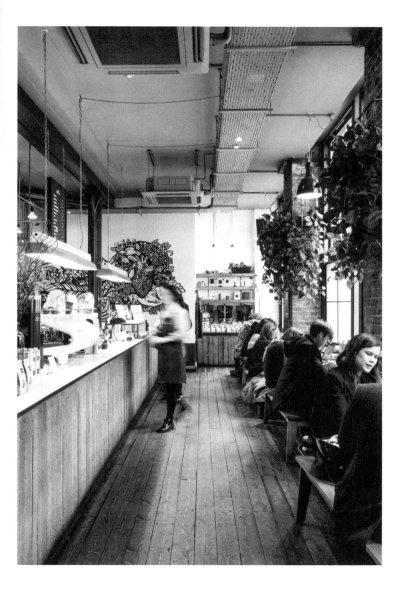

16

Climpson & Sons
Coffee shop and roastery

One of the original pioneers of the city's specialty coffee scene, Climpson has been waking up East Londoners since 2002. The competition for a coveted spot on the benches outside is fierce, and at busy times the queue for a brew snakes down Broadway Market. On Saturdays, when the market is on, you can also pick up a quick fix at Climpson's Coffee Cart a hundred metres down the road near the canal.

67 Broadway Market, E8 4PH
climpsonandsons.com

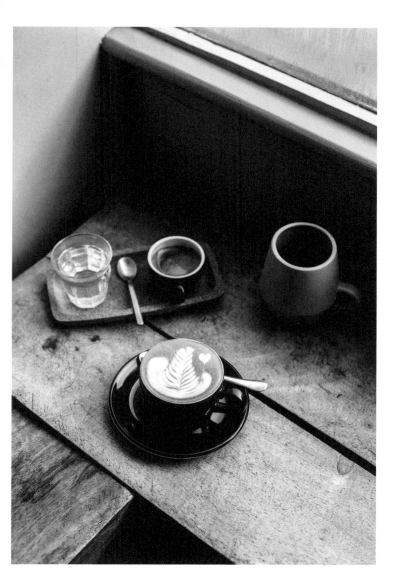

17
Nude Espresso
Coffee shop and roastery

Hanbury Street has not one but two manifes-
tations of this coffee haven. The flagship café
at number 26 is just right for a leisurely latte
and all-day brunches, while the dedicated
roastery opposite is a magnet for coffee
geeks. From Thursdays to Saturdays you
can stock up on Nude's full complement
of beans, savour the flavours in-house and
nibble on freshly baked banana bread.

25 and 26 Hanbury Street, E1 6QR
Other branches: 8 Bell Lane, E1 7LA
and 4 Market Street, E1 6DT
nudeespresso.com

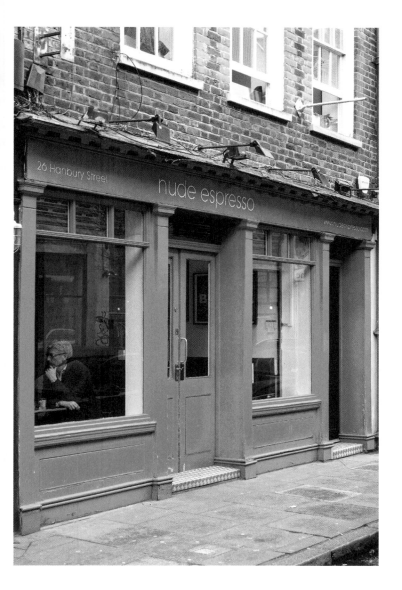

18
Allpress
Coffee shop and roastery

It's a tough contest, but this coffee shop and
roastery from Down Under serves some of the
best espressos in E8. Watch a batch of beans
completing their roasting cycle while you
taste the finished product in the sparse café
area. The sandwiches are deceptively filling,
while wooden seats and a lack of wifi keeps the
laptops away – more room for caffeine purists.
Bag a spot in the front garden and you'll almost
forget you're on a Dalston thoroughfare.

55 Dalston Lane, E8 2NG
uk.allpressespresso.com

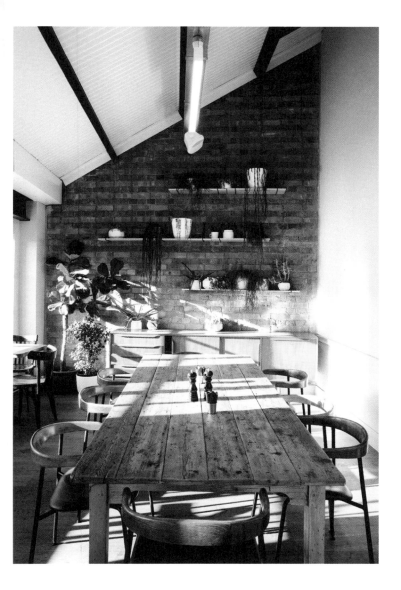

19
Leila's Shop
Café and grocery

If Shoreditch is a village, Leila's is the local
store and café. It has an honest approach to
fresh, organic produce, much of which powers
its seasonal menu of simple but completely
mouth-watering brunches and lunches. Try
the eggs with sage on a Sunday morning
followed by some grocery shopping next door.
Understated yet spectacular: it's a must.

15-17 Calvert Avenue, E2 7JP
twitter.com/leilas_shop

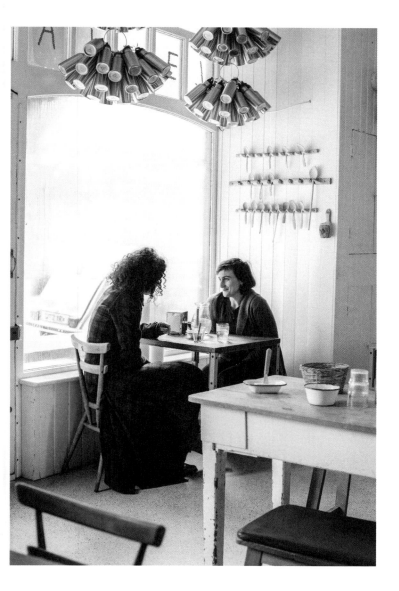

20

Uchi

Japanese restaurant

You'd never expect to find this Japanese
culinary delight hidden on a residential
backstreet in Clapton. Even so, a free table
at Uchi is a precious thing. Everything
about this restaurant is satisfying, from
the handsome crockery and careful
presentation to the rotating board of
specials – fingers crossed it features the
black rice veg tempura roll on your visit.

144 Clarence Road, E5 8DY
uchihackney.com

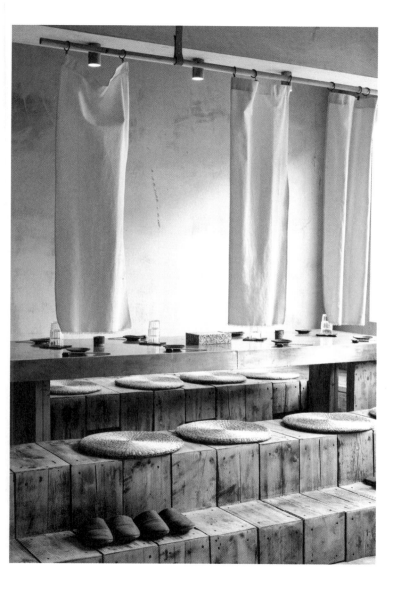

21

Legs

Wine-focused restaurant

Opposite the Hackney Walk fashion centre
on a quiet corner of Morning Lane is one
of Hackney's best restaurants. With only 24
covers you'll be lucky to get a seat, but the
seasonal and simple European-inspired small
plates are worth no end of waiting. Our advice:
bag a spot at the bar and watch the charismatic
ponytailed chef Magnus Reid work his magic.

120 Morning Lane, E9 6LH
legsrestaurant.com

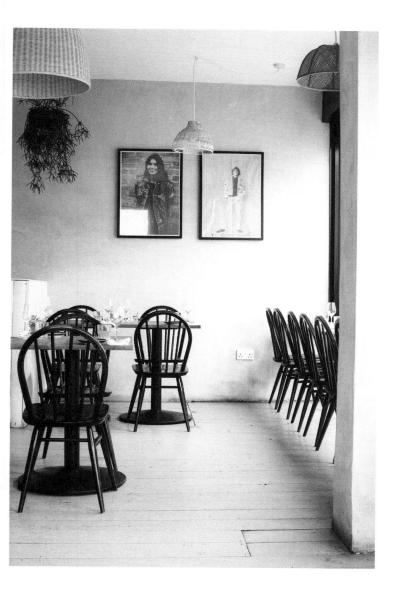

22

Bistrotheque
Modern European restaurant

A pioneer of fashionable East London
eateries, after 13 years this stylish restaurant
is still as popular as ever. You'll feel like
you've been let in on a secret as you ascend
the quiet staircase off a Bethnal Green back
street to the airy, white-walled dining room.
They make a mean pre-dinner cocktail at
the Manchichi Bar, but weekend brunch
is great too – especially when there's a
pianist to soundtrack your eggs Benedict.

23-27 Wadeson Street, E2 9DR
bistrotheque.com

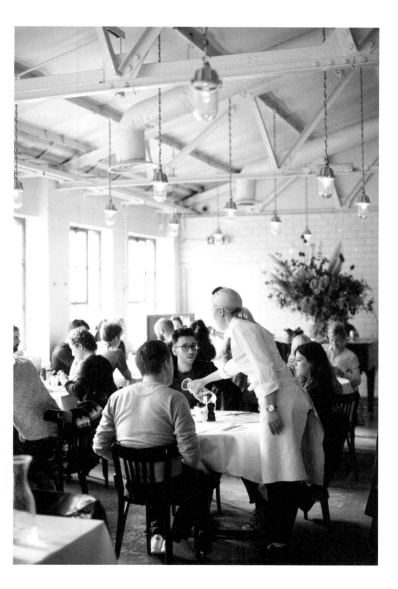

23

Pidgin

Set-menu restaurant

A Michelin-starred restaurant on a quiet
byway near London Fields? You bet. Despite
being really very small, Pidgin has been making
a big name for itself, with a four-course set
menu that changes every week but always
mixes up surprising textures and flavours.
The presentation can feel a tad OTT, but
those foams, brittles and gels are worth
savouring: every mouthful is a delight.

52 Wilton Way, E8 1BG
pidginlondon.com

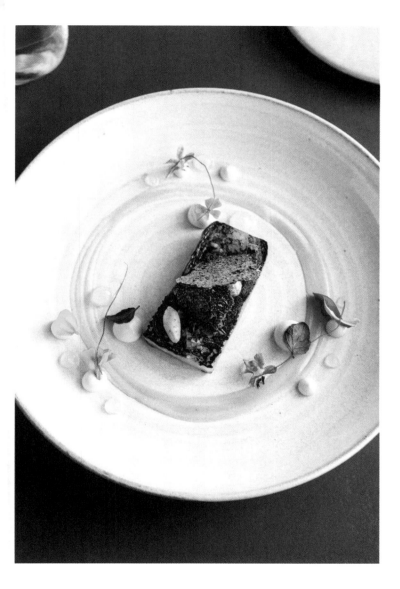

24

E5 Bakehouse
Bakery and coffee shop

This bakery and coffee shop on a quiet street
by London Fields makes the best sourdough
in East London, hands down. Alongside
those incredible fresh loaves, E5 also dishes
up delicious coffee and a dangerously good
selection of handmade cakes. Follow the
sweet, yeasty smell into their airy railway
arch, grab a seat at a communal table and
order some slabs of buttered toast with
all the spreads you could wish for.

Arch 395, Mentmore Terrace, E8 3PH
e5bakehouse.com

25

Pavilion Café

Lakeside café

The one problem with this beloved café and
bakery is that it's just too damn popular.
But don't be put off by the queues: even
at the height of summer there's plenty of
space on the outdoor communal tables
for brunching locals, families, dog walkers
and morning-after Tinder dates. Their
classic fry-ups are dished out all day, but if
you want to try the divine Sri Lankan egg
hoppers, turn up early before they sell out.

Victoria Park, E9 7DE
pavilionbakery.com

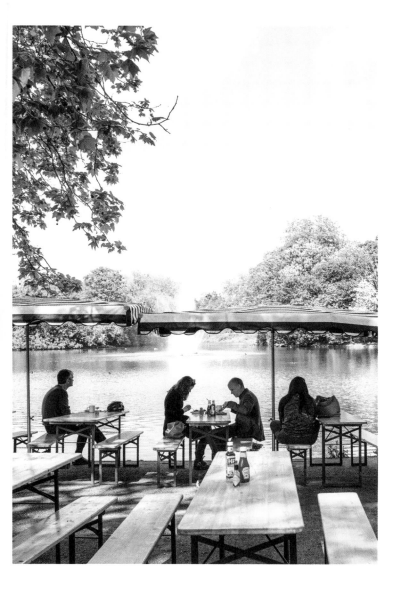

26

BúnBúnBún

Vietnamese restaurant

There's no shortage of vibrant Vietnamese
food at the bottom of Kingsland Road – in
fact, there were 14 restaurants on the 'Pho
Mile' last time we counted – but BúnBúnBún
is a relatively new and welcome addition.
They serve all the classics, but you should
opt for their specialty, the Hanoi street
food favourite Bun Cha: a big satisfying
bowl of rice noodles, lemongrass-marinated
pork, salad and fried spring rolls. Yum.

134B Kingsland Road, E2 8DY
bunbunbun.co

27

Sodo

Pizzeria

Clapton, Leyton and Stokey locals guard this
Upper Clapton pizza joint like a family secret,
booking up the handful of tables each night
to tuck into Sodo's delicious and decently
priced sourdough pizzas. The menu is limited
but always seasonal and the judicious wine
selection goes down a tad too easy. If you
can't get in, you can order takeaway – or head
to Sodo's new branch in Walthamstow.

*126 Upper Clapton Road, E5 9JY
and Hatherley Mews, E17 4QP
sodopizza.co.uk*

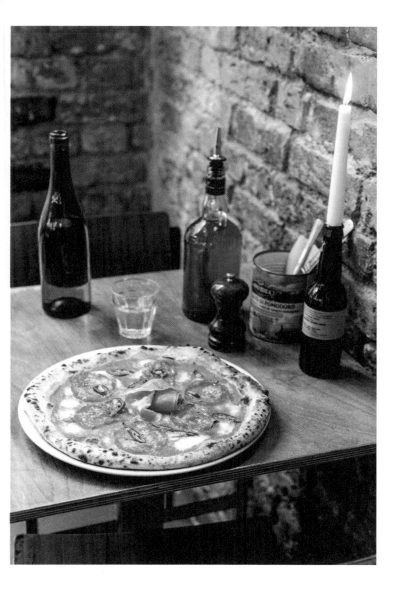

28

Morito

Tapas and mezze restaurant

First there was world-famous Moro in
Exmouth Market, then its tiny spin-off
Morito next door. Thankfully, the third
incarnation came to Hackney, this time with
space to fully appreciate its Spanish, North
African and Mediterranean deliciousness.
Sit at the grand marble horseshoe bar,
order a bit of everything (especially the
fried aubergine, pomegranate molasses and
feta) and experience pure happiness.

195 Hackney Road, E2 8JL
moritohackneyroad.co.uk

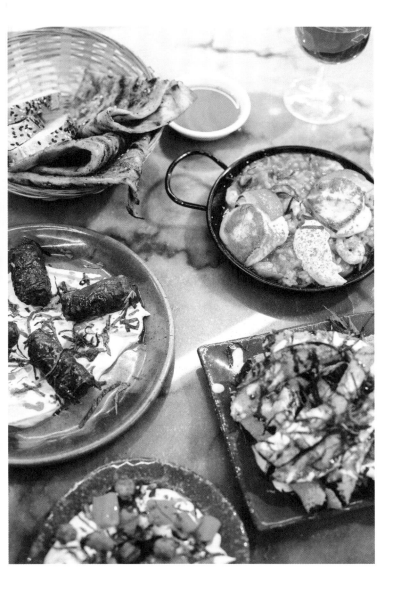

29

Berber & Q

Grill house

You'll never go hungry at this Middle Eastern-inspired grill house that sits under a Haggerston railway arch. Platters come out piled high with marinated grilled meat, pickles, dips and mezze sides, all washed down with cocktails or Berber's own specially brewed Crate beer. Despite the carnivore-centric menu, there are plenty of veggie delights including the cauliflower shawarma (order at least a half: it's the best thing on the menu).

Arch 338 Acton Mews, E8 4EA
berberandq.com

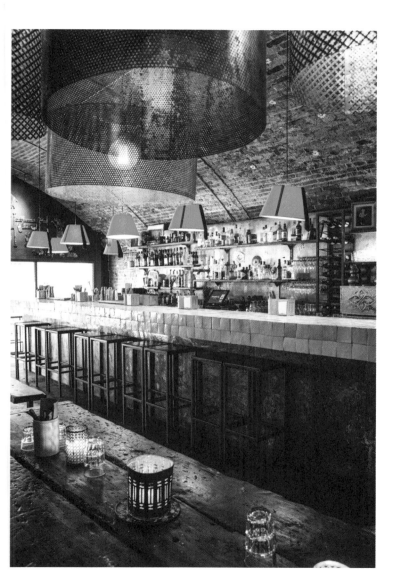

30
The Good Egg
Café and restaurant

Church Street is a bruncher's paradise, but
nothing quite hits the spot like The Good
Egg. Each weekend, hopefuls line up for
its ingeniously innovative and creatively
executed Israeli-infused nosh. There are eggs
aplenty, true, but the menus go far beyond
that with delicious collisions, such as bacon
and marbled egg pita with date jam, alongside
homemade pickles and house-smoked meats.
Book for dinner to sidestep the crowds.

93 Stoke Newington Church Street, N16 0AS
thegoodeggn16.com

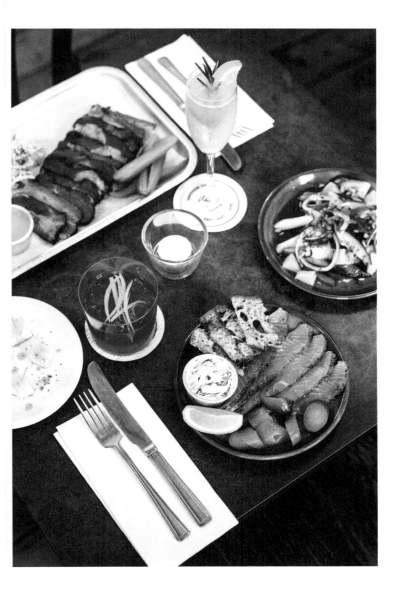

31
Som Saa
Thai bar and restaurant

Som Saa was so well loved as a Thai food
pop-up that it took them just three days
to crowdfund £700,000 to open their first
proper restaurant. Demand has only grown
for those fresh, exciting and impressively
spicy dishes that first enchanted the
crowds. Get the whole deep-fried sea bass
and don't be put off by the head – it's a
taste explosion. Bring a cold compress to
soothe those chilli-powered hot flushes.

43A Commercial Street, E1 6BD
somsaa.com

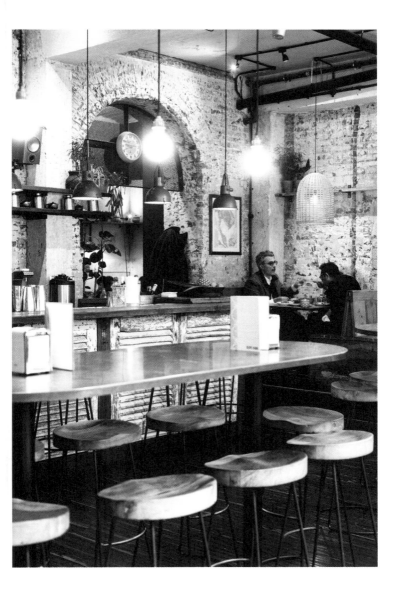

32

Jim's Café

Café and restaurant

A former greasy spoon and ice cream factory,
Jim's has been revamped into a proper caff
for modern Hackney. Many of the original
features remain, but with the addition of new
60s-style booths and bar stools. The menu has
been shaken up with local, organic produce,
freshly baked sourdough and reinvented
classics such as open-faced eel omelette. Ideal
for parents-on-duty and freelancers during the
week, and hungry brunchers at weekends.

59 Chatsworth Road, E5 0LH
instagram.com/jimscafe59

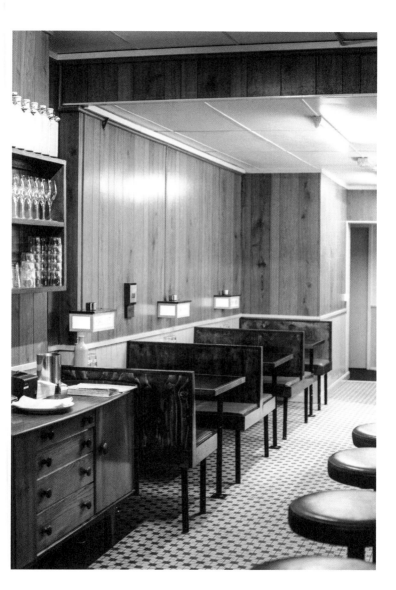

33

Lahpet

Burmese restaurant

If you are tired of the busy Vietnamese
restaurants of Shoreditch or the cacophony
of Brick Lane, Lahpet serves up the subtle
and much rarer Asian flavours of Burma
(Myanmar) in a quiet street behind London
Fields. Don't miss the signature tea leaf salad
and the shrimp and watercress fritters. But
be warned, as of writing, this place was still a
pop-up, open only in the evenings. It deserves
to be permanent – but do check the website.

5 Helmsley Place, E8 3SB
lahpet.co.uk

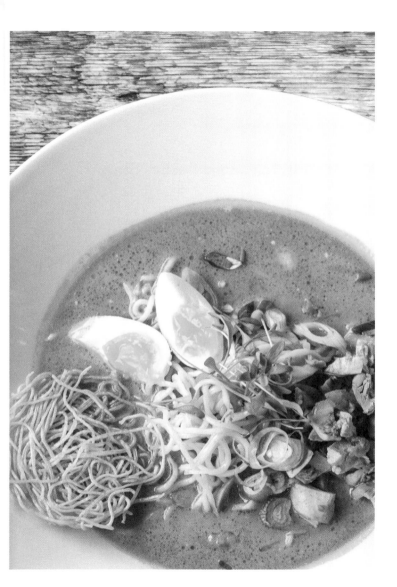

34

Brick Lane Beigel Shops

Bakeries

If there's one thing that divides East
Londoners, it's which of the two 24-hour
Brick Lane beigel shops is best. 'The yellow
one' and 'the white one' are both masters of
their trade, cramming freshly baked beigels
with juicy salt beef and mustard or smoked
salmon and cream cheese, but the queue in
the white-fronted Beigel Bake is always longer,
plus they have a winning edge: fresh black
rye bread on Thursdays and Saturdays only.

155 Brick Lane and 159 Brick Lane, E1 6SB

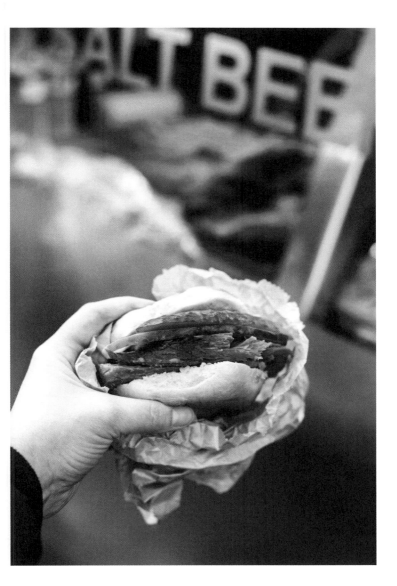

35

E. Pellicci

Traditional café

Opened in 1900 and still run by the same
family, this Grade-II listed art deco greasy
spoon in Bethnal Green is an East End
institution, cranking out first rate fry-ups, pie
and mash, Italian specials, strong builder's tea
and side orders of lively banter. At breakfast
and lunchtimes, the wood-panelled and
Formica interior heaves with regulars reading
well-thumbed newspapers and gossiping
with staff. Share a table and join the buzz.

332 Bethnal Green Road, E2 0AG
epellicci.com

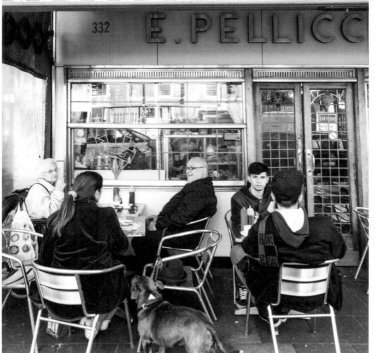

36

Crate Brewery

Bar and pizzeria

Summer nights were made to be spent at
this canalside temple to craft beer – eating
stone-baked pizza, watching narrowboats glide
by, while sucking on a hoppy home-brewed
ale. Unfortunately, almost everyone else
in Hackney Wick feels the same; it can get
impossibly busy on a warm evening. The good
news is that its ever-changing selection of
freshly brewed beers and crispy-based pizzas
taste great all year round, whatever the weather.

The White Building, Queen's Yard, E9 5EN
cratebrewery.com

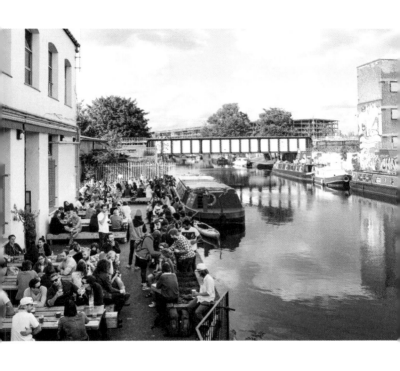

37

Broadway Market

Saturday market

Stretching down from London Fields to
Regent's Canal, Broadway Market is the
place to pick up the best that East London
has to offer. Fashionable, hungry and mostly
hung-over Londoners make the pilgrimage
every Saturday to savour the street food and
to browse the handmade goodies ranging
from unusual cheeses to haggis toasties to
baby clothes. Get there early to beat the
crowds, secure a seat outside a café and
indulge in some serious people-watching.

Broadway Market, E8 4QJ, Saturday 9am–5pm
broadwaymarket.co.uk

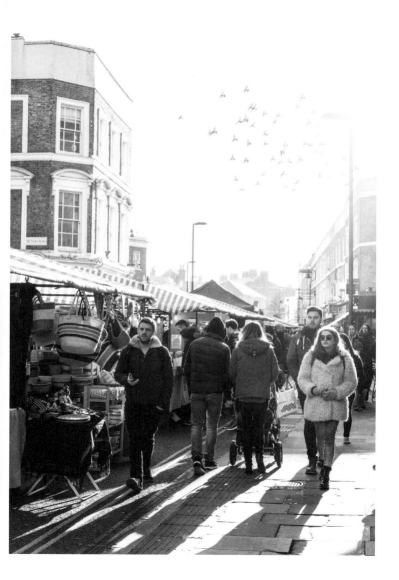

38

Victoria Park

Park

Serving East Enders since 1845, the 86-hectare
Vicky Park is the emerald in East London's
crown and a park for all seasons. Wrap up
for an autumn stroll along the canal, take a
weekend meander around the boating lake
and pagoda (stopping off at the Pavilion
Café for breakfast / no.25), gawp at the
annual Guy Fawkes extravaganza or head
to one of the music festivals that take
over the park's east side each summer.

Grove Road, E3 5TB, 7am - dusk

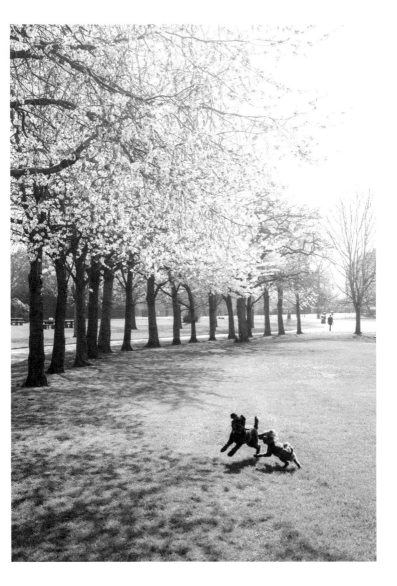

39
Columbia Road
Sunday flower market

Every Sunday, this sleepy Victorian street is
transformed into a frenzy of fragrant flowers
and foliage. Locals arrive ridiculously early
to stock up on seasonal blooms, houseplants
and bulbs, and banter with stallholders
before the tourists descend around noon,
when it becomes too busy to move. But
what's the hurry? Wait until packing-up
time around 3pm and you'll come away
with armfuls of flowers at bargain prices.

Columbia Road, E2 7RG, Sunday 8am-3pm
columbiaroad.info

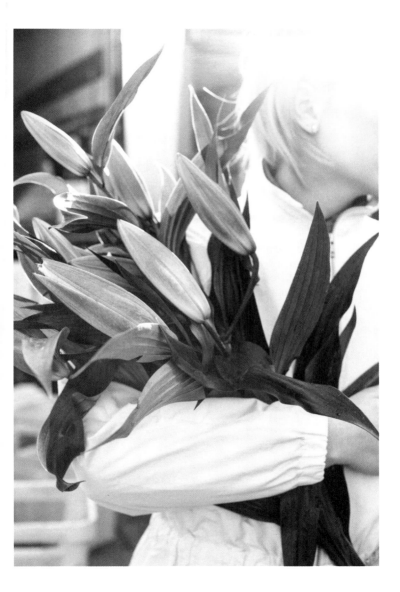

40

London Fields Lido

Outdoor swimming pool

There's no better place for a dip in East London than London Fields Lido. The Olympic-sized heated pool is open all year round, with sweaty, impatient queues across the park in summer and hardcore shivering swimmers dashing in during the colder months. It's always popular for pre-work swims, but those in the know dive in on a weekend evening when the pool is open until 9pm and practically empty.

London Fields West Side, E8 3EU

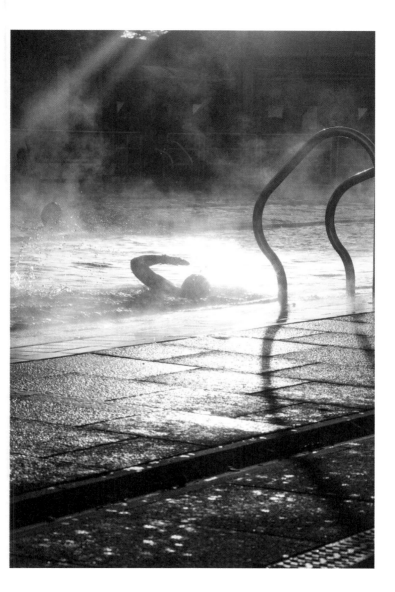

41

Dalston Eastern Curve Garden
Café and garden

You could easily miss this wonderful community garden hidden opposite Dalston Junction station. A scrap of the old Eastern Curve railway line has been transformed, offering shady sitting-spots amongst trees and flowers, wildlife-friendly planting, and raised beds where locals can nurture herbs and vegetables. At the garden pavilion there's a bar, a pizza oven, sofas and blankets for winter, while in the summer they stay open late for drinks, acoustic gigs and lantern-lit parties.

13 Dalston Lane, E8 3DF
dalstongarden.org

42

The Line

Sculpture trail

East London's lack of sculpture trails finally
got fixed when The Line opened in 2015.
Discover 13 modern and contemporary public
sculptures by artists including Damien Hirst,
Martin Creed and Eduardo Paolozzi, playfully
dotted along a three-mile route that takes
you from Stratford to North Greenwich
via some other significant (but slightly
less arty) East London sights: the Queen
Elizabeth Olympic Park, the O2 Arena and
the Emirates Air Line cable car (which now,
finally, has a purpose thanks to this trail).

Start on Stratford High Street
the-line.org

43

The Geffrye
Museum

Housed in a splendid eighteenth-century
almshouse in Shoreditch, the Geffrye is a
true one-off, dedicated to the home lives
and styles of the capital's denizens from
1600 onwards. The recreated living rooms of
Londoners across the ages open the door on
what has (and hasn't) changed. From April
to October you can amble around the period
gardens and see how Londoners have pruned
their topiary over the last four centuries.

136 Kingsland Road, E2 8EA
geffrye-museum.org.uk

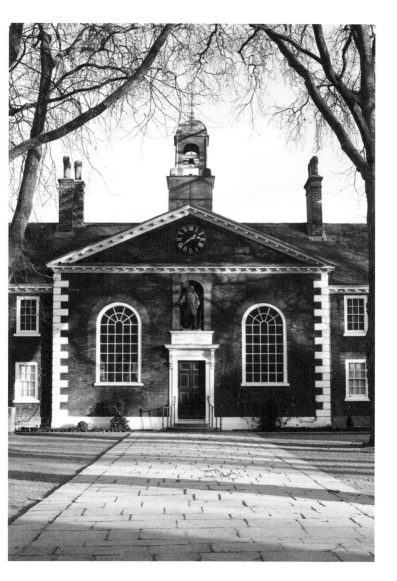

44

Whitechapel Gallery
Gallery

Founded in 1901, this cherished public gallery surpassed its mission to 'bring great art to the people of East London' long ago, scooping a jaw-dropping series of debut shows for some of art's biggest names – Pollock, Hockney, Rothko, Kahlo, Freud, and locals Gilbert & George among them. Leave time to forage the shelves of its bookshop (an outpost of Koenig Books) and fortify yourself at the wholesome Whitechapel Refectory or the After Hours bar.

77-82 Whitechapel High Street, E1 7QX.
whitechapelgallery.org

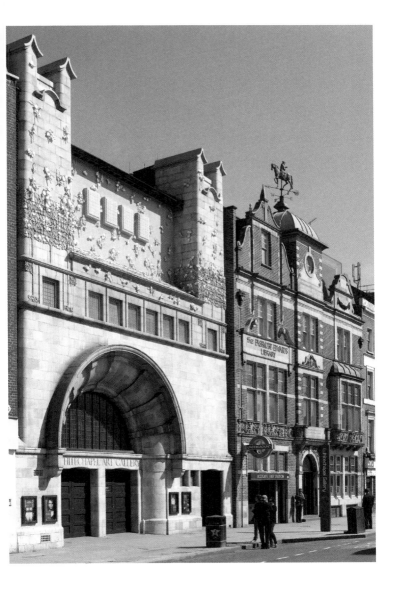

45

Chisenhale Gallery

Gallery

In a former industrial building on Regent's
Canal, this trendsetting exhibition space
is the gallery to see new work by future
art stars and to find out what's happening
right now in the contemporary art world.
Shows cross all mediums including film,
painting and sculpture, and there's an exciting
programme of on- and off-site events and talks,
including performances in Victoria Park.

64 Chisenhale Road, E3 5QZ
chisenhale.org.uk

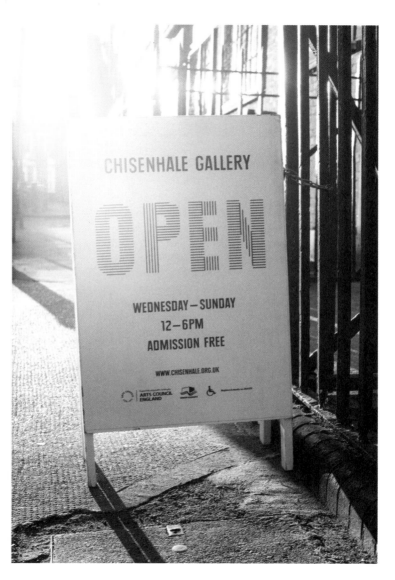

46

Maureen Paley

Gallery

Beehive-haired art pioneer Maureen Paley
moved to this Bethnal Green backstreet in
1999, making this a pioneering commercial
gallery in the East End. Since then a cluster
of other spaces have moved in around her,
but this original still cuts above the rest for its
consistently innovative unveiling of fresh talent
alongside 'old' masters, including the likes
of Wolfgang Tillmans and Gillian Wearing.

21 Herald Street, E2 6JT
maureenpaley.com

47

William Morris Gallery
Museum

Forget Brian Harvey from East 17; the
baddest boy to come out of Walthamstow
was surely renegade interior designer and
craftsman, William Morris. A tour around
his lavish teenage home is to be steeped in
his life and work, not to mention his socialist
campaigning, and will surely leave you
inspired to do some major home redecoration.
Leave time for tea in the café and a stroll
around the adjoining Lloyd Park, where the
young Morris pretended to fight dragons.

Lloyd Park, 531 Forest Road, E17 4PP
wmgallery.org.uk

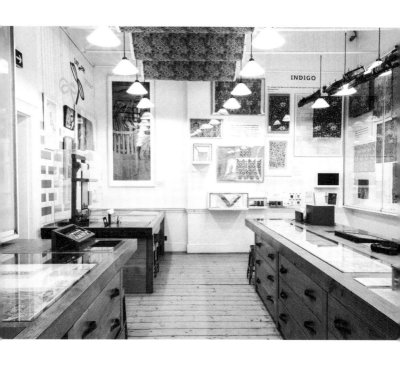

48

The Clowns'
Gallery-Museum

Museum

Dalston has a playful secret – it's the home of London's only museum dedicated to the art of clowning. Enter the small door behind Holy Trinity Church on the first Friday of every month (or by appointment) to discover the colourful collection of paintings, photographs, costumes, props and the enchanting 'clown egg register': a collection of hand-painted ceramic eggs documenting the unique look of each joker since the time of Joseph Grimaldi.

Cumberland Close, E8 3DY
clownsgallery.co.uk

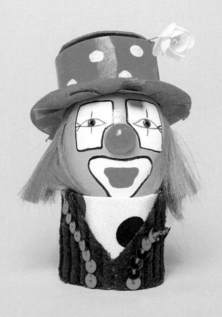

49

Dennis Severs' House
Museum

Stepping into this atmospheric Georgian residence is like walking onto the set for a painting by an Old Master. That's exactly the effect eccentric American Severs was after, when he turned the rooms into ten intimate scenes in the life of a fictional family of Huguenot silk-weavers, making them uncannily as if they'd only just walked out. Take a candlelit tour and be prepared to time-travel.

18 Folgate Street, E1 6BX
dennissevershouse.co.uk

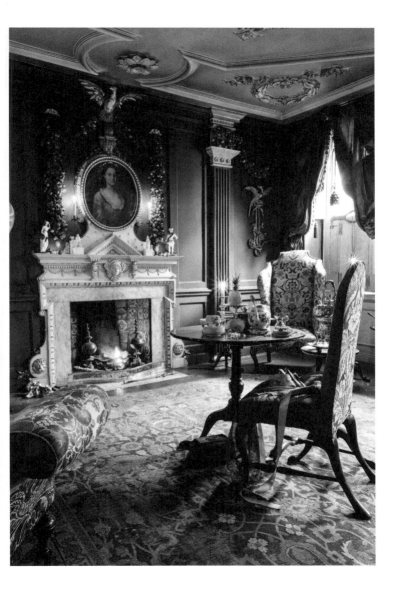

50

The Marksman

Pub and restaurant

The Marksman has been notching up awards
since its reopening in 2015. The secret of its
success is the way it marries top-drawer
Michelin-lauded grub with the traditional
character of your local wood-panelled boozer.
Real ale aficionados, wine buffs and high-flying
gastronauts mingle seamlessly, whether
nestled on bar stools and leather banquettes
downstairs, or chowing down in the fresh
and contemporary dining room upstairs.

254 Hackney Road, E2 7SJ
marksmanpublichouse.com

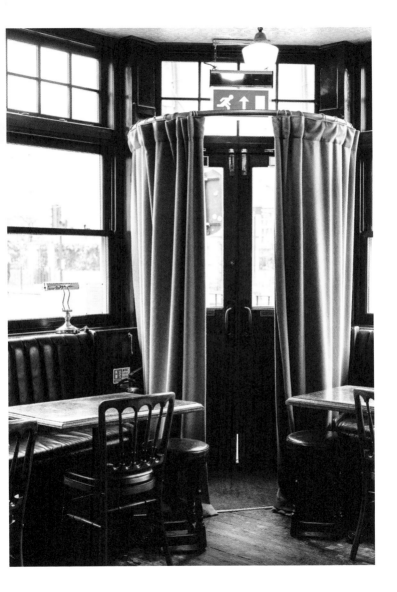

51

Sager + Wilde
Wine bar

East End date night? This sleek corner bar
is the place. The steamy windows and jazz
soundtrack make for a relaxed, romantic
setting, while staff are on hand to guide you as
you delve into the small but dynamic wine list.
Line your stomach with a few tasty bar snacks
including the legendary jalapeño and cheddar
cheese toastie – the ideal accompaniment
to… well, pretty much anything.

193 Hackney Road, E2 8JL
sagerandwilde.com

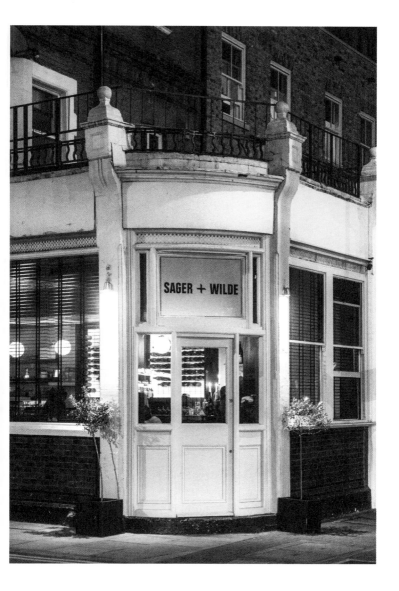

52

Café Oto

Music venue

You can rock up at this experimental music and
arts venue night or day and there'll always be
something to tickle your ears or taste buds. A
great café and work spot by day, at night there's
a bar and a diverse programme of concerts,
festivals, book launches and film screenings.
With cheap tickets on the door, it's worth
dropping in even if you've never heard of the
band playing (and you probably won't have).

18-22 Ashwin Street, E8 3DL
cafeoto.co.uk

53

Genesis
Cinema

Anyone living in Whitechapel or Stepney is
lucky to have the five-screen Genesis as their
local independent cinema. It's the perfect place
to catch new films on the big screen, showing
major releases in a laid back, arty setting as
well as hosting poetry nights, gigs and festivals.
You'd be hard pressed to find cheaper cinema
tickets anywhere in East London. And where
else can you watch a flick with snacks from
the local 100-year-old bakery, Rinkoff?

93-95 Mile End Road, E1 4UJ
genesiscinema.co.uk

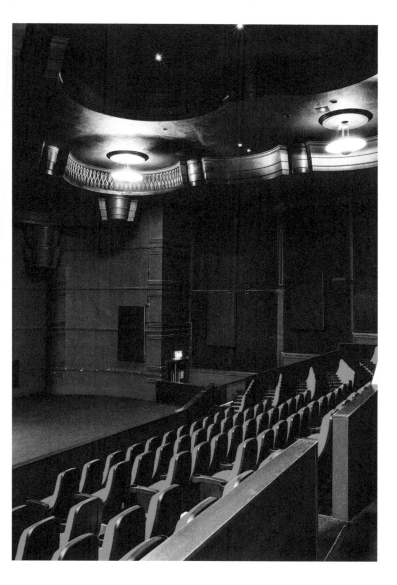

54
Wilton's Music Hall
Theatre & concert hall

After a four-year restoration project costing £4 million, the stage lights are back on at the world's oldest surviving grand music hall. The renovations haven't plastered over the crumbly charm of this gem in a quiet Aldgate backstreet, which hosts an impressive line-up of fringe theatre, music, cabaret, workshops and tours. Get down well before doors to soak up some East End history (and a pre-show drink) in the gorgeous Georgian Mahogany Bar.

1 Graces Alley, E1 8JB
wiltons.org.uk

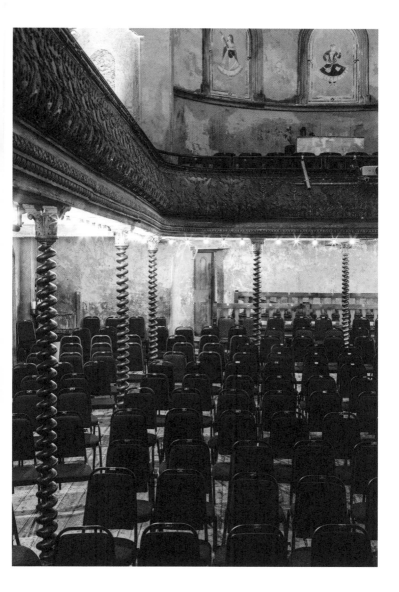

55

Ruby's

Bar

A retro cinema sign above what was once Ruby House 3 Chinese takeaway reveals a doorway to a judiciously discreet underground cocktail bar and lounge. The soft lighting, exposed brickwork and killer chilli apple martinis are perfect for cosy meet ups. For those who want to really party, the kind people at Ruby's keep the spacious subterranean lounge open late at weekends for drinking and dancing.

76 Stoke Newington Road, N16 7XB
rubysdalston.com

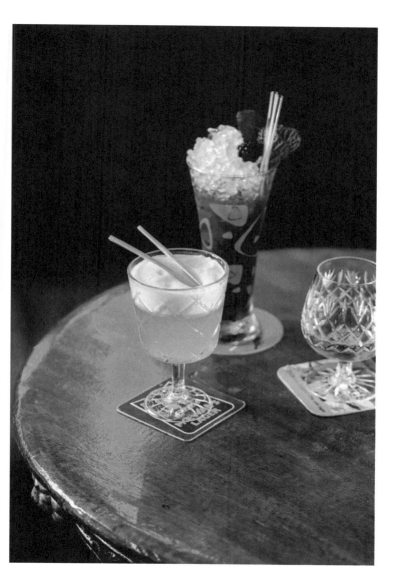

56

Moth Club

Music venue

This revamped army serviceman's club is the
perfect combination of old and new East
London: a classic British institution given a
hip upgrade. Many of the original furnishings
remain, except now there's a gold glittery
ceiling that's worth a visit alone. With an events
line-up that riffs on traditional members'
club entertainment – gigs, bingo, karaoke,
club nights, film screenings and raunchy
cabaret – there's something fun every night.

Old Trades Hall, Valette Street, E9 6NU
mothclub.co.uk

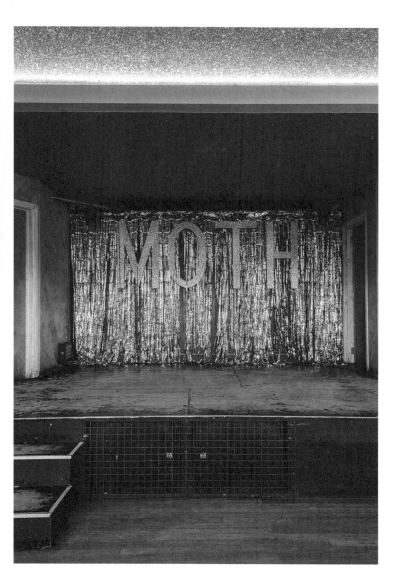

57
Servant Jazz Quarters
Music venue

The only way you'd stumble across this tiny
venue tucked away on a Dalston side street is
by clocking the gig-goers smoking outside. You
can pop in to the ground-floor bar for a sneaky
cocktail (they do a handily timed happy hour)
or head downstairs to see up-and-coming
bands up close. And don't be fooled: there's
plenty more than just jazz on offer.

10A Bradbury Street, N16 8JN
servantjazzquarters.com

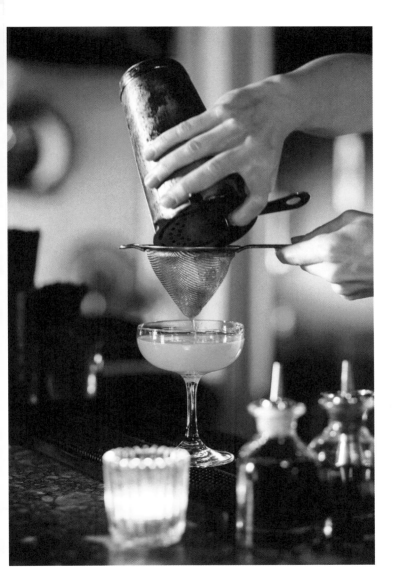

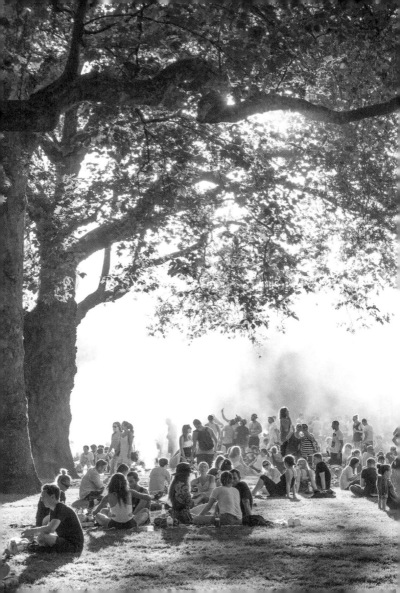

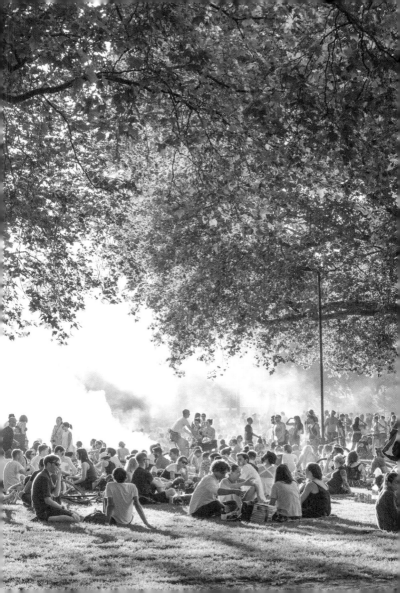

NOTES

NOTES

East London: An opinionated guide
First edition, second printing

First published by Hoxton Mini Press, London 2017
Copyright © Hoxton Mini Press 2017
All rights reserved

Compiled by Hoxton Mini Press
Written by Sonya Barber

All photographs © Charlotte Schreiber except for:
Image for Nude Espresso © Laura Zepp
Images for Pavilion, Bistrotheque, E. Pellicci
and Crate Brewery © Helen Cathcart
Image for London Fields Lido © Madeleine Waller
Image for Café Oto © Dawid Laskowski
Image for Lahpet © Kathrin Werner
Image for Maureen Paley © Maureen Paley, 2016,
(Image credit: Wolfgang Tillmans, *The State We're In, A.*)
Image for the Clowns' Gallery-Museum © Luke Stephenson

Design by Hoxton Mini Press / Matthew Young
Copyedited and proofread by Harry Adès
Special thanks to Sam Wolfson and to all of the places featured

The content and information in this guide has been
compiled based on facts available at the time of going to
press. We strongly advise you to check each location's
website before visiting to avoid any disappointment.

Printed and bound by Livonia Print, Latvia

ISBN: 978-1-910566-22-0
A CIP catalogue record for this book is
available from the British Library.

MIX
Paper from
responsible sources
FSC
www.fsc.org FSC® C002795